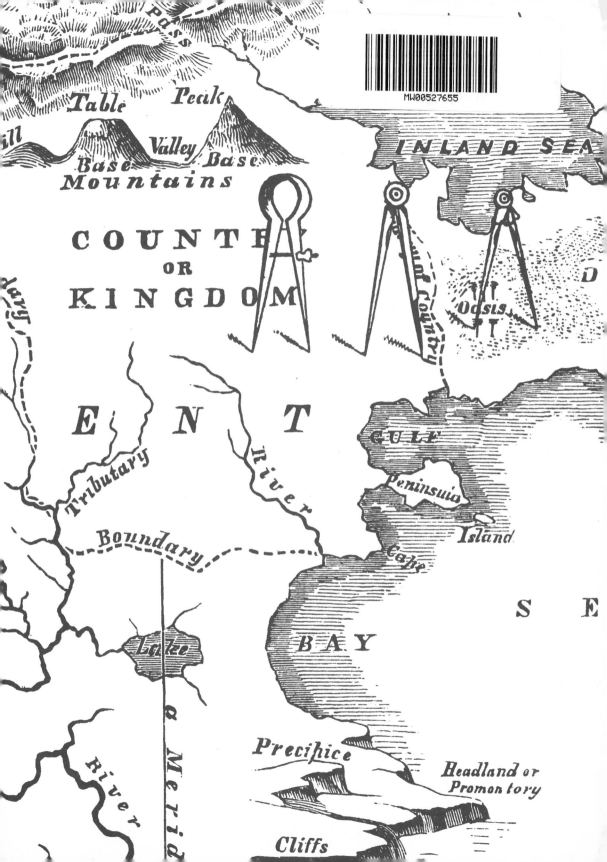

Pass

Table Peak

ill Valley
Base Base
Mountains

INLAND SEA

COUNTRY
OR
KINGDOM

Oasis D

E N T

GULF

Tributary River

Peninsula

Boundary

Island

Cape

Lake

S E

a Merid

BAY

River

Precipice

Headland or
Promontory

Cliffs

HOW TO USE THIS BOOK

Artist's Fix 7120R-M
1 Thumbscrew; 2 Blade; 3 Brace

Perhaps there are artists or writers out there somewhere who have never been intimidated by a blank canvas or page — for whom life's beauty and fury come streaming out in orchestrated flourishes and paragraphs. This notebook is not for them. This notebook is a creativity catalyst for those of us who realize that the pursuit of art is boundless. We who have the great good fortune to brood on matters of word and image may from time to time need a prompt (Webster's defines *prompt* as "spur to action") or a friend to help us keep on creating. If, as you embark on your daily application of pigment to paper, your fingers and mind should freeze: relax, breathe deep, turn to a fresh new page in this notebook, and fix your gaze upon the image you find there. Then close your eyes and take three more breaths whilst thinking of nothing at all. Empty your mind, breathing deep from your belly, until there is no image, no thought.

Now, begin to write or draw. (Yes, you may open your eyes now.) Your creativity will be sparked by details carved over one hundred years ago by a wood engraver's tool. Undoubtedly those engraved lines will impart some rhythm to the synaptic dance occurring within your mind. They will collaborate with your creation. Allow the old engraving master to be your friend, even your guide should you need one. The adventurer allows herself to get lost in the forest, but the artist must describe a path through — one we can understand and navigate. Good luck and remember to look up at something far away every ten minutes so you don't go nearsighted.

Get to it! Create! Write! Live! It is only through rocky patches that we get to the smooth blue waters (remember: save the oceans). Hey, would you stop reading this already and get to work?

Enjoy,
JOHNNY CARRERA

Dec. 13. 2016.

今天和南大英语文学系教授何宁交流了 WA. 他是真的...
提出了不少好建议。现在就是一门心思冲政经，当作高考，拼命
一搏，不想失败或其他，专注眼前的感觉很好。

之前还很焦虑。觉得给的 condition 挺难的，很有风险，因此
不能集中精神而陷入恐惧。同时周围人录了许多好学校，还有
期末，IA dd1 Clash，不知道为什么...该 prioritize 哪一个。 peer pressure

但也有其他失败默默承受的人们。Jensen RISD录了。雷蒙哥大
录了。Zhu 康奈尔录了。lucy 圣路易斯录了。陈逸凡斯坦福 拒了。
许可 2个帝国 理工。Grace UCL.

鸡血。。。
小排球现在是鸡血来源。月实在太帅了。我喜欢人的共同点
即 聪明。。

前段时间 WKL 迷之用语言问我去不去看马克西姆，若虑到他
也是司机，不得不觉得他是有预谋的 233 后又都用文字问了。
是试探？ 我倒是不经意想来。

前段时间 主动远离了些，不想那么爱她，果然也不那么爱她了。
可现在又觉得还很爱她..."欺负她到哭不出来"

"包含了丝许焦躁和烦闷的小小破绽"
一定不会让它们争到的.

Abalone (Shell of)
39R-MN

Jan / 25 / 2017.

好久了...

想做一件 Elsa 一样的旗袍。王子路发了一张图片，WKL 讲话 "像 Lily Wu" Fran 说他是不是对我还有顾忌。Grace 说 "人都是只点戏。"

1.22 Fran 过生同，不 租了 Airbnb。自己做了菜。累翻了，不过她很开心。再前一天去上海面试 Mount Holyoke，玩得很累。再之前去香港 NTK，完了培训，感觉少慌了一点。

啊今天 元旦前和 Grace 住了一晚，在她家，没告诉 Fran。但很喜欢那间卧室，睡得很安心。早上吃了她妈做的饭。又吃了鱼四季。睡前她疯狂给我安利美妆博主。还有了 2013 LSE IH 的录取 7%。坚定了一下。但还是不安。拿到了纸质 offer，再 更有实感了。转战 PTE。

1.15 申请全递了。非常喜欢 Sarah Lawrence。但 Tracy 说 LSE 依然是性价比最高的 Best Choice。相当于 USA Top 15。海超也那么说。

我仍然对 Fran 申 Wellesley 的任何消息感到不爽。虽然那不是我最喜欢的学校。但就因为分数而不能申请(SAT)。相当不爽。我的个人特质更适合这所学校。她一直都太顺利了。黄鸡被 Chicago 拒，Cindy Ed Bryn Mawr。不过她被剑桥拒，Mike 被牛津拒。

我是自私的爱。

Acorn 13RS-W4

Agave 129R-W4

Feb / 5 / 2017.

"西班牙" LSE 的 群里的 妹子. 之前 填错了 Condition
把 Predicted Grades 填在了 Received 里面. 她说" ~~努力~~
"每天 慌张的 努力".

我一直没有 信心. 无法相信 别人. 包括自己.

可是 "不相信自己的人没有努力的价值".

"哪怕只有一点希望也要拼尽全力"

我已经没什么好犹豫. 退缩的了.

我无路可退.

Air Brush 4970R-ME
c Color cup; t Tube; v Valve

2017. 2. 12.

　从香港上课回来，累到瘫。让人想起准备美国考试的那段日子。

　三年前，正是我最痛苦的月子。鸡汤喝了不少，鸡血打了不成少，可终归是自己感动，没什任何结果，也不是完全这样？至少坚持到最后了。可谁知道潜意识里有没有放弃呢？ 那年马刺夺冠，三年过去，邓肯已经留下他的球衣高挂襄坏。

Anvil 188R-W4

Argali 2215R-W

我也即将进入另一个赛场。手握心让人羡慕的入场卷，我得紧紧抓好，把握住这难求的机会。我是打败心有个人得到这个席位的，因此，实力已被肯定，可以更有信心一些。我在学习上不那么自信。那么，就让进场前最后一次考验当作对自己的磨炼，从此打开更多的信心之门。

"没有 不相信自己的人没有努力的价值。" 我从现在开始，相信自己，相信正确的努力可以让我得到想要的。

"有压力证明我有考上的希望。"

想成为像手辅鞠那样，背负责任和伤痛，却又可以自信地战斗，笑容如大波丝菊般灿灿烂的女人。

不再迷茫。

Backhand 8941-M

2.18.

为了同林不停变奔跑，毫不犹豫豫地前进.
我还差得很远. But turn it upside down.
诊视得到的一切。不再迷茫. 想到什么就用超强的行动力
去做.

即使只有一毫米的希望也要拼尽全力。

我可能, 有点厌倦了。

Badger 298R-MN

2.25.

倦怠期.

即使寂寞得窒息，也要守护坚强的自己.

Bee Fly 320R-MN

3.16.

收到了 港大. Northeastern.
　　　　第一份 奖学金
　　　　第一个 unconditional offer.

Maths IA 得到了 赞扬.
对她恢复了感情
又想做个 Historian.
· 用自己的节奏生活的勇气.

~~朋村~~
目标明确.
我得到了很好的机会
这次. 我要抓推住。

Bipolar 785R-WN

Brahma
282R-W4

3.19.

小萨拉要了我.

想去.

但这两天效率奇低.

otter ~~symbo~~ 病.

感觉被困住了

想要逃离.

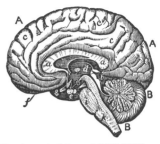

Brain of Man 361R-MN
Right half of Brain: AA Cerebrum
BB Cerebellum aa Corpus Callosum
ccc Convolutions d Third Ventrical
e Pituitary Body f Olfactory Lobe
g Optic Nerve i Pons Varolii
k Medulla Oblongata

Brussels Sprouts
754R-MN

3.26.

LSE	小萨拉
•名声相对较大	•艺术好
•专业排名前(QS第6?)	•师资可以
•伦敦→ 城市喜欢	•人少, 且大家扑在艺术上, 与教授接
• → 工作实习机会多	触机会多
•实地考察过. 期望不会虚高	•靠近大城市, 但不在中心.
•专业人少, 老师学术可以	•学姐酷美帅 聊得来
•图书馆藏可以	•staff/氛围亲切友好 liberal.
	•师. 素养可以.
	•资源竞争没有那么激烈
•艺术可以学的机率为0.	•出state 鲜有人知
•功利(也许历史专业好点?)	•无排名
•职业接口主要是投行. 资讯公司	•纽约三年前去不喜欢
•与未来校友画风不同, 大家看上	•没考察过. 理想现实也许有偏差
去既 competitive 又焦虑.	•身边邦?
•英国学制, 三年一考定 Degree	
•专业无法后悔.	
•office hour 不敷好约, 101机会少	
•多是大课	
•大城市中间. 浪.	

4.10

Oral History + Musical Theatre

写成

Book → 加批注 → 提醒读者 Bias

CONSTELLATIONS

Conferring Knighthood With Airbrush 742-DI

Constrictor 666D-I

Clio 523R-W4

Corncrake 267-DI

Line of Beauty 2006R-MN (on a palette)

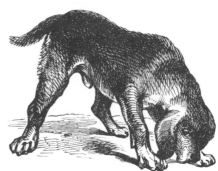

Cuban Blood-hound 143-D4

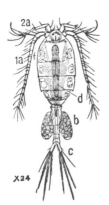

Copepoda 863R-M (*Cyclops coronatus*)
1a Antenna; 2a Ant-
ennule; t Carapace; d
Intestine; b Egg Sacs;
c Caudal Appendages

Burnisher 290R-W4

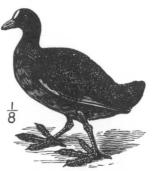

Coot (*Fulica atra*) 1189R-WN

Corn Fly Larva 945R-MN

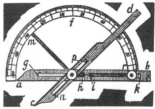

Contact Goniometer 1737R-WN

2017.8.1

今夏买的衣服大概占 我衣服总数的一半.

音乐剧工作室
↓
演员 + 作词曲 + Marketing

2018/2/18

真是过了很久. 大学以来第一次写日记, 最近去看 counseling 了,
前陈子真怀疑自己 desperate , mood 多悲伤, 开心不起来. 暴.
觉得未来没有希望, 被 trap 住了. 其实 hesitate 的不是
职业如何, 挣钱多少, 而是 "我真的热爱 Theatre " 可以
一直坚持吗? 即使在逆境? 下学期想 学更多音乐
及作曲, 也多尝试一条路. 也想 像雯和至言一样, 坚定
不疑的走下去. 想写一部关于 comfort women 的 ~~The~~
play, 从 historian and activist 的角度. 时常想
放弃, 但从没真正放弃. 真的很想知道我生命中的
"那件事" 是什么.

Candelabrum
454R-W4

戏剧教育.英文/双语
↑
(唱歌.做音乐)

2个选项.

同时创业.晚上打工.

1. 2年半毕业后找工作. 断绝关系, 自己存钱以后再读研

 ╲ 第二年找戏剧教师/去公司实习

 ╲ 毕业经济独立立

2. 用她的钱读工作A, 再忍受 1~3年

目前来说第一个选项. 不能再忍受了. 不可能期望情况会

变如好. 不可能.

实现第一条 → 今年回国期间做 Workshop 来 积累经验

明年暑假假回国实习 → 交七幕实习.

Cantharsis
934R-W4

Capstan
8092-W

Cercaria
322-WN

Cereus (*C. gicanteus*)
& Indians 4890R-MN

Cheetah 718R-MN

Cisco 2391R-MN

Clews 714R-WN
A Heart Clew; B Ring Clew

Compony
542R-WN

Conjugate
550R-W4

Counterbalance 828R-W4

Cymbals 610R-W4

Dandie Dinmont 1280R-WN

Diadelphous Stamens
1045R-W4

Dial of Timepiece
13989-MN

Dice
1245R-W

Dingo (*Canus dingo*)
1284R-MN

Diopsis 1375RR-WI

Diodon
1055R-W4

Diploid
1791R-WN

California Type Case 56-187-M

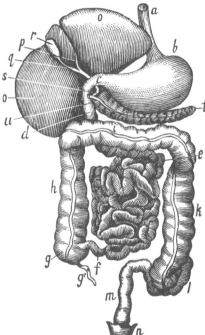
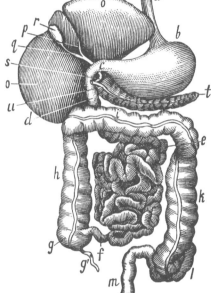

Digestive Apparatus 1292R-W

Burin 289-W4

Diptera
1385R-MN

Anamorphosis
176R-W4

Scissors 7033R-ML

Didynamous?
1052R-W4

Differential
4033R-W9

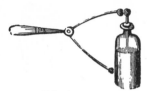

**Discharger
1057R-WI**

Drum
1484R-WN

Eccentric 1355R-MN
a Eccentric; b Strap; c Rod

Egret 745-WN
(*Ardea garzetta*)

Envelope
9657-M
The check's in the mail.

Equitant
1094R-W4

Fault
1448R-WN

Fez 1495R-WN

Four-way Cock 1635R-WN

French Horn
1412R-W4

Friction Cones 1417-W4

Gaiter 1501R-W4

X 3

B

A

Gapeworm 1634R-MN

Gauntlet 1641R-W4

American Mountain Hare
931R-M (*Lepus americanus*)

Harp
1748R-W4

Bust 293R-WI

Crayon 837R-MN

Crayon 584R-W4

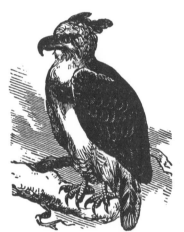

"Aaaaay!"
14171-M

Harpy 1749R-W4
(*Harpyia destructor*)

Harpsichord 5985R-ML

Harrier 1692R-MN

Hawkbill 3954-MN
(*Eretmochelys imbricata*)

Grass Finch 888-MN
(*Poocaetes gramineus*)

Greyhound 1544R-W4

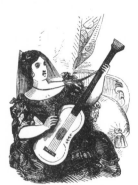

Guitar 525 WI

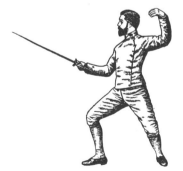

Guard
("En garde!")
5660R-ML

Hammock 1809R-WN

Handcuffs 8290-M

a *b*

Hemiptera
1823R-MN
(*Arma spinosa*)
(True Bug)

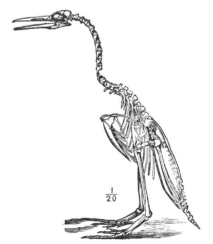

$\frac{1}{20}$

Hesperornis 1700R-MN
Science is Measurement

House Cat 13063R-ML

Hydrozoa 1949R-MN
(*Tiaropsis diademata*)

c Idle Wheel 1827R-W9

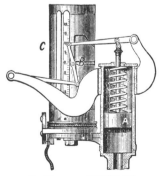

Indicator 1892R-M
A Small piston; B Pencil

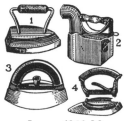

Irons 6053-M

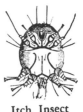

Itch Insect
1918R-MN
(Scabie)

Jack
6581R-M

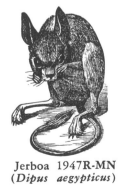

Jerboa 1947R-MN
(*Dipus aegypticus*)

Indicator Card 1880R-M4

Incumbent
1836R-W4

Incised
1832R-W4

Insectivore 1881R-MN
(*Sorex thomsoni*)

Indian Corn
1837R-W4

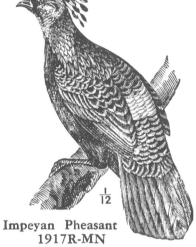

Impeyan Pheasant
1917R-MN
(*Lophophorus impeyanus*)

Art is Observation

Insignia of the Order
of the Garter 1508R-WN

Inescutcheon
1839R-W9

the Artist
1076R-W4

Indicator 108R-MN
B Pencil; C Drum

Indian Pipe
2107R-MN
(*Monotropa uniflora*)

G

Jim-crow 19-65-M

Johnson Grass
1639R-MN

Junk 5556R-W

Kahau 2022R-M
(*Semnopithecus nasalis*)

Kingfisher 133R-W
(*Ceryle alcyon*)

Knuckle
Joint
2139R-MN

Labiate
1965R-W

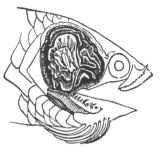

Labyrinthici 2085R-MN
(Of the tree climbing Perch)

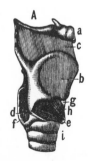

Larynx 1192-WN

Lazy Tongs 1249-WN

**Log, Line,
& Glass
8050-W**

Loom 19997R-W4

Loligo (*Loligo pealei*) 2125R-MN

Maioid Crab 2216R-W4
(*Parthenope horrida*)

**Mangle
8455-M**

Manifold 1286-WN

PLANE

AA

ACTUAL

HORIZON

HORIZON

V.

a'

a

b'

b

BASE LINE

S.P.

Monkey
(*Cebidae*)
2212R-W4

Monkey (c)
(*Lemuroidea*)
2213-W4

Palette
8090-W

Monkey (do)
(*Simiadae*)
2211R-W4

Molars 3659R-W4

The Monitor 2311R-W4

Monosepalous
1841R-WI

Moloch 1362-MN
(*M. horridus*)

Your Monkey Wrench

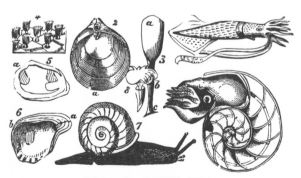

Mollusks 2801R-W4

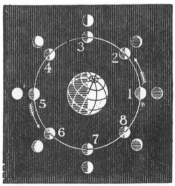

Moon Phases 1590-M

Mattress 8457-M

Medusa 1374-WN
(*Callinema ornata*)

Metronome
(Maelzel's)
6714R-M

Monkey Wrench 2327R-MN

Mural Crown
2279R-M4

Neck Tie
14188-M

Nest 2359R-W4

Noctiluca
2337R-MN

Nodulous
2362R-W4

Nut
1415-WN

Oarlocks 3473R-M

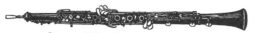

Oboe (Hautboy) 1056-WN

Oil Cup
1648-WN

Ovoid
2424R-M4

Oscules of Sponge
2628R-MN

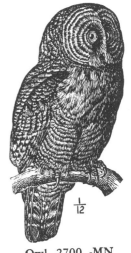

Owl 2700 -MN
(Great Gray)
(*Ulula cinerea*)

Pegasus

Pendant 6824R-M

Pennants 2495R-MN

Penninerved
1612-WN

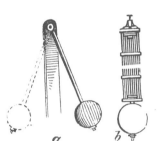

Pendulums 2556R-W4
a Common; b Gridiron

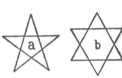

Pentacles 7048R-M
a Pentagram

Pepper 2561R-W

Pendant
2554R-W4

Pointing Apparatus
6905R-M

Pericarps 8219-WI
e,f poppy capsule
g *aristolochia* capsule

Pentagon
2557R-W

Monkey Wrench 2327R-MN

Penumbra 2560R-W

Percussion Lock
2562R-W

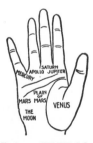

Palm 4717R-M
(Planetary)

Pansies
(*Viola tricolor*)
1554-WN

Pantograph 753R-MN

Parabola
2534R-W4

Pillory 2575R-W4

2464R-M
Pholas
(*P. bakeri*)

Party
2541-WI

Pika 2800R-W4
(*Lagomys pusillus*)

Pillow Block 1613-WN

Portland Vase
2606R-W4

Plunger Pump 2852R-MN

Prop
1994-WN

Pterichthys
(*P. milleri*)
2650R-MN

Pseudopods of *Difflugia*
2979R-MN

Pterylosis
1541-WN

Puma (*Felis concolor*) 2491R-MN

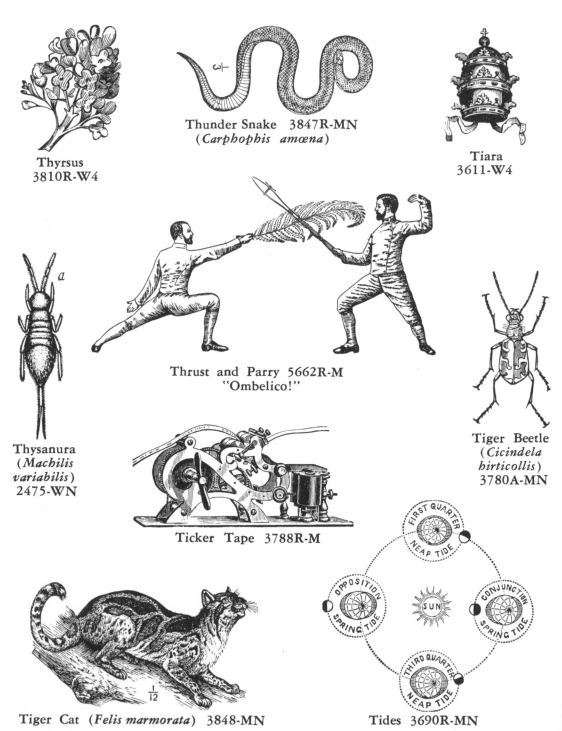

Thyrsus
3810R-W4

Thunder Snake 3847R-MN
(*Carphophis amœna*)

Tiara
3611-W4

Thysanura
(*Machilis
variabilis*)
2475-WN

Thrust and Parry 5662R-M
"Ombelico!"

Tiger Beetle
(*Cicindela
hirticollis*)
3780A-MN

Ticker Tape 3788R-M

Tiger Cat (*Felis marmorata*) 3848-MN

Tides 3690R-MN

Quart
8456-M

Quinone 14859-ML
1 Paraquinone; 2 Onthoquinone

Quohog 2867R-MN
(*Venus mercenaria*)

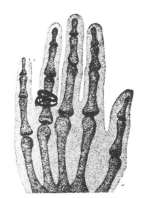

Radiograph 6945R-ME

Rack & Pinion 2995R-MN

Railroad
Spike
1391RR-W

Raspberries
(*Rubus idaeus*)
2996R-MN

Ratchet Wheel 2994-MN
b Reciprocating Lever;
c Ratchet; d Pawl

Razors 6951R-ML
1 Ordinary (Straight);
2 Safety

Receptacle
(of Dandelion)
2961R-MN

Rooster 6984R-M

Reindeer 2907R-W4
(*Cervus tarandus*)

Scissors 9453-M

Scyllæa 3411R-MN
(*Scyllæa edwardsii*)

Shrapnel
2195-WN

Shuttlecock
3455·MN

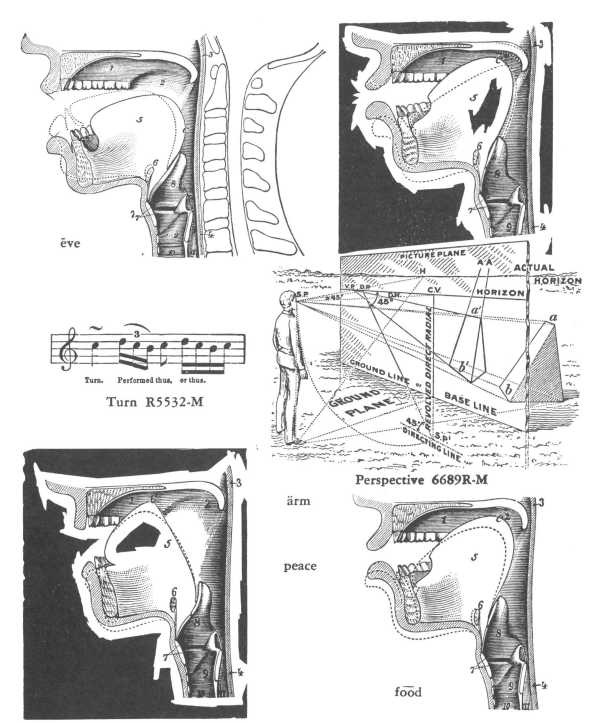

ēve

Turn R5532-M

Perspective 6689R-M

ärm

peace

care

fōod

10 Windpipe; 11 Oesophagus

Sieve
3180-W4

Sistrum
3135R-W4

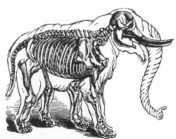

Skeleton of Elephant 3188-W4

Steam Engine
2145-MN

Statoblast 4040R-W

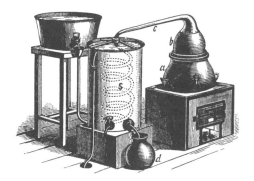

Still 3540R-WN
a Boiler; b Head; c Tube; s Worm in
cold water; d Receiver

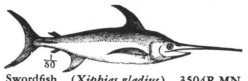

Swordfish (*Xiphias gladius*) 3504R-MN

Table Saw 1990-WN

Teasel 3598R-W4
(*Dipsacus fullonum*)

Tedder 14010-M

Tellina
3712R-M

Terminus
3602R-W4

Terminal
Bud
2452-MN

Terrapin 3895R-MN
(*Malaclemmys palustris*)

Ticker Tape 3788R-M

Treadmill 3626R-W4

Wheel Animal
4161R-MN
(*Melicerta biloba*)

Whirling Table 4034R-M4
a Footboard; b Wheel; c Pulley;
d Arm; ef Uprights

Ratlines
2956R-MN

Razor Shell
(*Solen ensis*)
3017R-MN

Whales 891-WN

Portcrayon 3604R-W4

Wheat
a Bald
b Bearded
15288-MN

Protractor 6923R-M

Rhizostomata 3052-MN

Lute 2018R-W4

Trowel 3642R-M4

Turnstile 3657R-W4

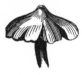

Umbonate
3868R-W4

Umbrella Ant
2606-MN
b Worker w. leaf

Universal Joints 3873R-W4
1 Single; ab Shafts; c Cross.
2 Double; ab Shafts; cc Crosses;
d Connecting Link.

$\frac{1}{2}$

Ursula 2619-MN
(*Limenitis astyanax*)

Vacuum Coffee
Maker 8-JF-M

Velum 3965R-MN
(of *Dysmorphosa fulgurans*)
n Young Zooids budding

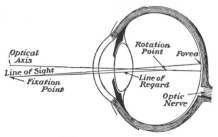

Vision 6004R-ML

Visite
3892R-W4

Voluta
2689R-MN

Waffle Iron 9408-M

Whack! 8084-W

Wax Palm 4031R-W4
(*Ceroxylon andicola*)

Wicker Basket
8578-M

Zebra Wolf 4191R-M

Whelk 2812-MN

Ratchet Wheel 2994-MN
b Reciprocating Lever;
c Ratchet; d Pawl

Wheel 4032R-W4

Stylus 14557-M

Whidah Bird
4172R-MN

Leviathan 846-WN

Whipworm
2802-WN
s Spicule

Whelk 2813-MN
(*Buccinum tottenii*)

Receivers
2896R-W4

Wasn't Wisint 207R-W
What is it? (Aurochs)

Wentletrap 2811-WN
(*Scalaria pretiosa*)

Mountainous Distr

Mountain

Chain

Pass

Rivulets

Rivulets

Crater

River

Tribut

Volcano

Lake

wn or City

C O N T I

Right Bank of River

Left Bank of

GULF

Village

Promontory

Road

Tributary River

River

Village

SEA

ISLAND

Canal

Forest

Isthmus

Arm of Delta

Arm of Delta

Mar

PEN

Delta

Mor

City